Shelburne Ontario in Colour Photos, Saving Our History One Photo at a Time

Photography by Barbara Raué
2013

Series Name: Cruising Ontario

Book 46: Shelburne

Cover photo: #111 – House of Jelly

Series Name: Cruising Ontario
Saving Our History One Photo at a Time

Photos now in full colour
Check the Appendixes in the back of each book for
descriptions of architectural terms and building styles

Book 33: Southampton
Book 34: Jarvis
Book 35: Hagersville
Book 37: Simcoe
Book 38: Cambridge Part 1 – Galt Book 1
Book 39: Cambridge Part 1 – Galt Book 2
Book 40: Cambridge Part 2 – Preston
Book 41: Cambridge Part 3 – Hespeler
Book 42: Kitchener Book 1
Book 43: Kitchener Book 2
Book 46: Shelburne
Book 50: Orangeville Beginnings
Book 51: Orangeville on Broadway

Other Books by Barbara Raue

Coins of Gold

Arrows, Indians and Love

The Life and Times of Barbara
Volume 1: Inventions That Have Enhanced My Life
Volume 2: Entertainment That I Have Enjoyed
Volume 3: East Coast Trips
Volume 4: Olympics Have Always Intrigued Me
Volume 5: Wonders of the World
Volume 6: Caribbean Cruises We Have Enjoyed
Volume 7: Animals
Volume 8: Storms and Other Major Disasters in My Lifetime
Volume 9: Wars, Terrorist Attacks and Major Disasters

The Cromwell Family Book

Visit Barbara's website to view all of her books
http://barbararaue.ericraue.com

Shelburne

Shelburne is a town in Dufferin County, Ontario located at the intersection of Highway 10 and Highway 89. Shelburne is best known for the Annual Canadian Championship Fiddling Contest that is held each August.

Settlement of Melancthon Township began in the late 1840s at the time of the construction of the Toronto-Sydenham Road. By the 1860s settlers had moved into the Shelburne area and in 1865 William Jelly, one of the community's earliest inhabitants, opened the British Canadian Hotel commonly known as Jelly's Tavern. Within a year, the settlement included a post office named Shelburne, after the Earl of Shelburne of Ireland. In 1872, William and his brother John surveyed a village plot in anticipation of the arrival of the Toronto, Grey and Bruce Railway. Rapid economic growth followed.

Laurel

The hamlet of Laurel is located on the 5th Line (or County Road 12) in the Township of Amaranth.

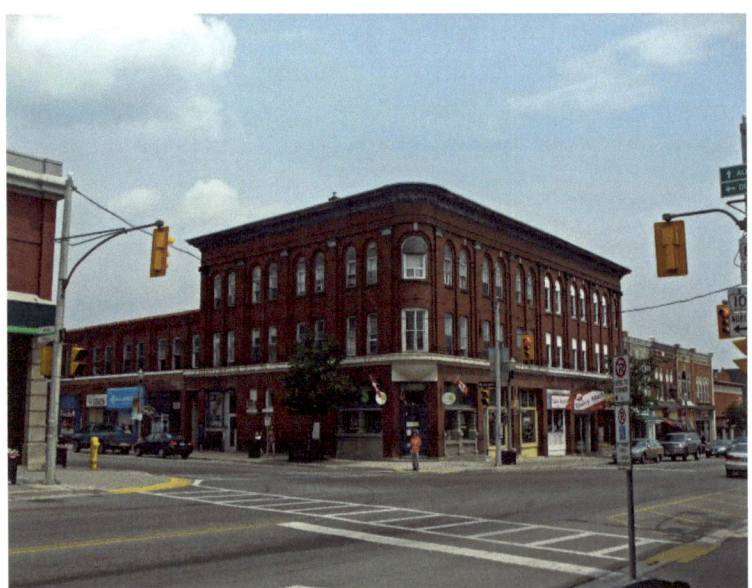

Owen Sound Street corner in Shelburne

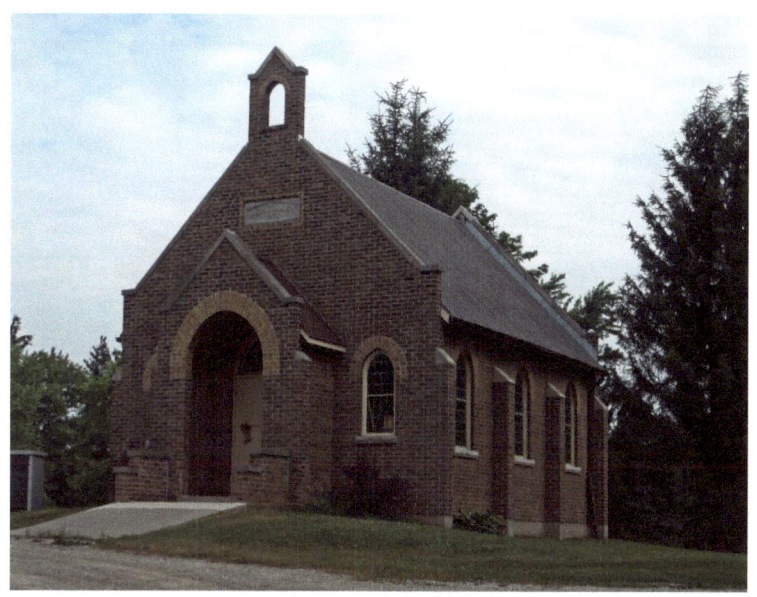

Mortuary - 1831

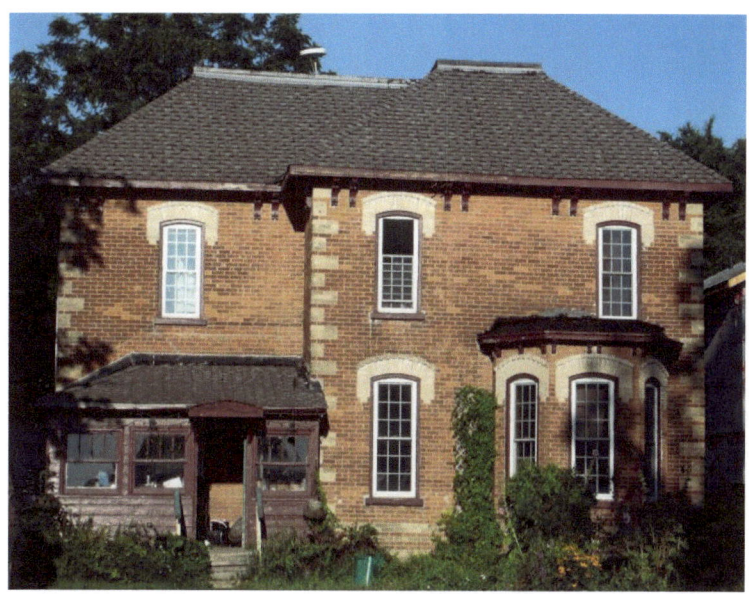

Italianate style – paired cornice brackets, buff-coloured window voussoirs, corner quoins, hipped roof

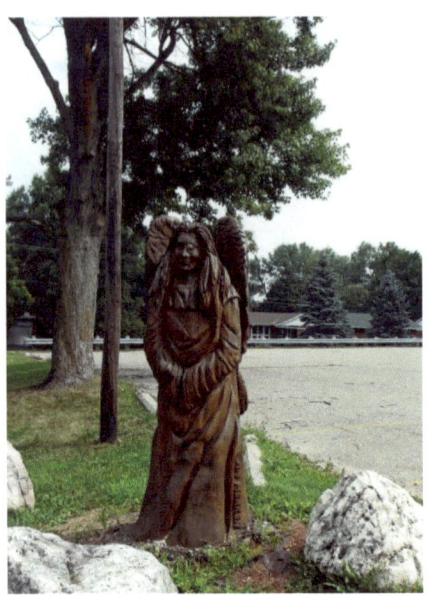

Angel carving by Jim Menken

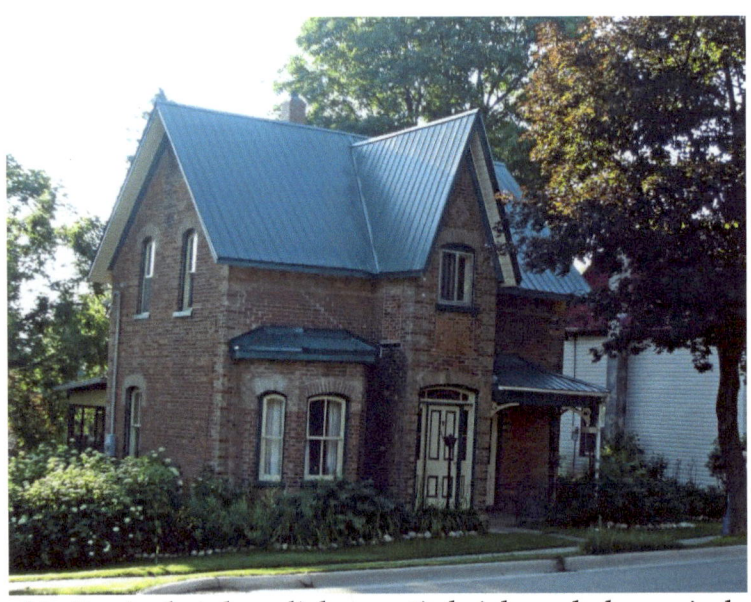

Gothic Revival style – dichromatic brickwork, bay window, steeply pitched gables

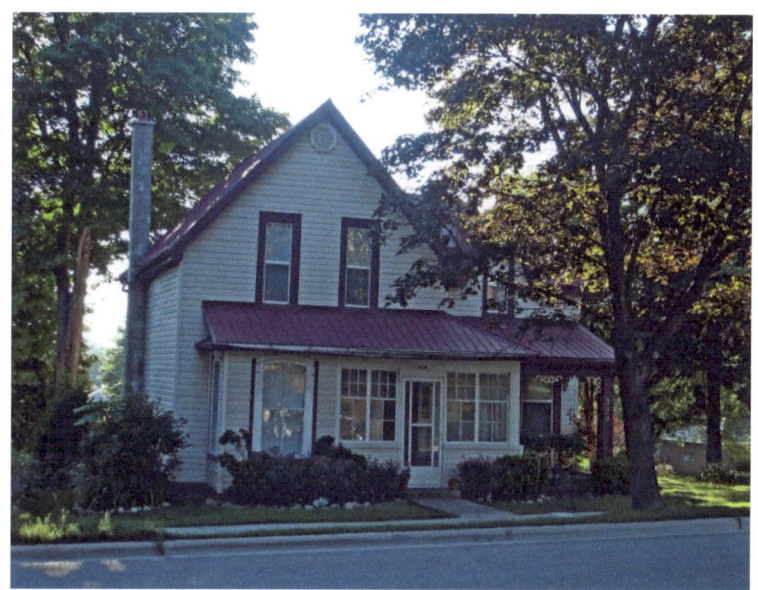

Gothic Revival

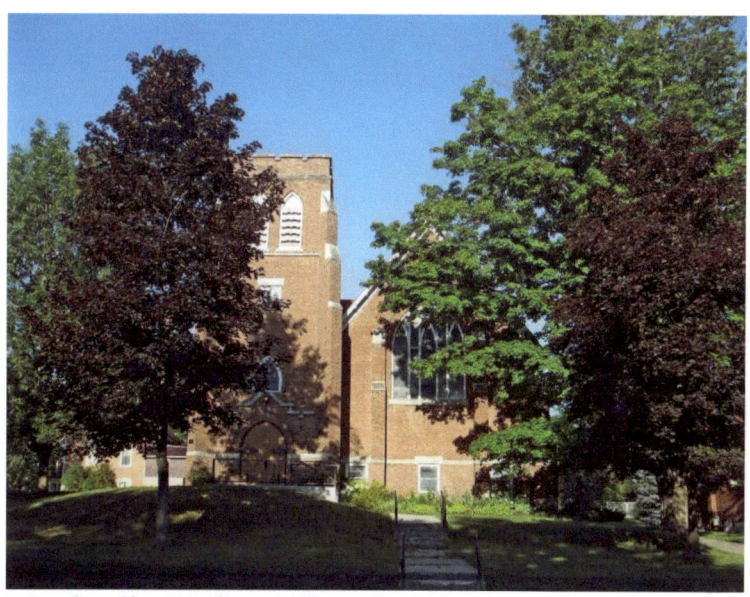

St. Paul's Anglican Church, 312 Owen Sound Street

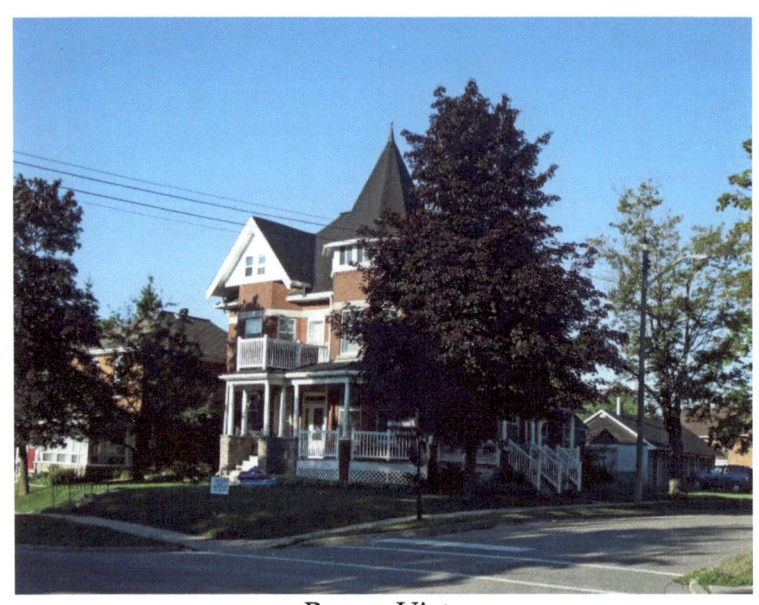

Buena Vista
230 Owen Sound Street at the corner of Second Avenue West

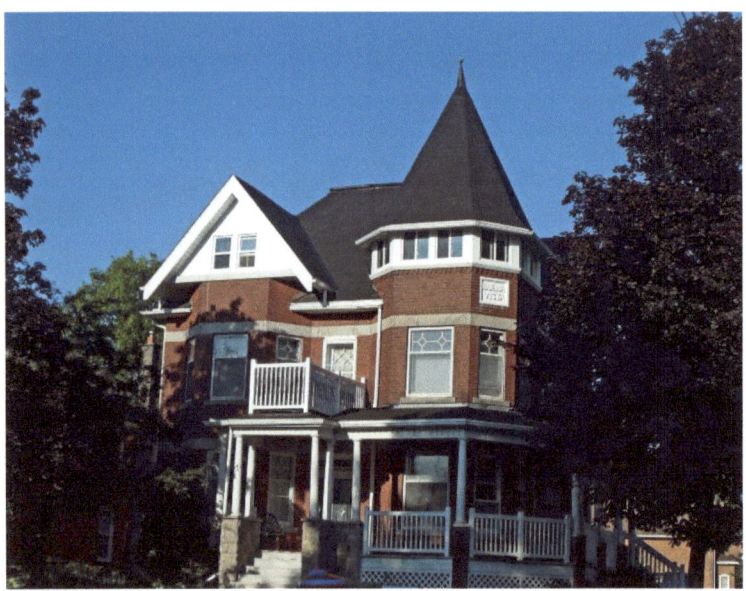

Queen Anne style – turret with cone-shaped roof

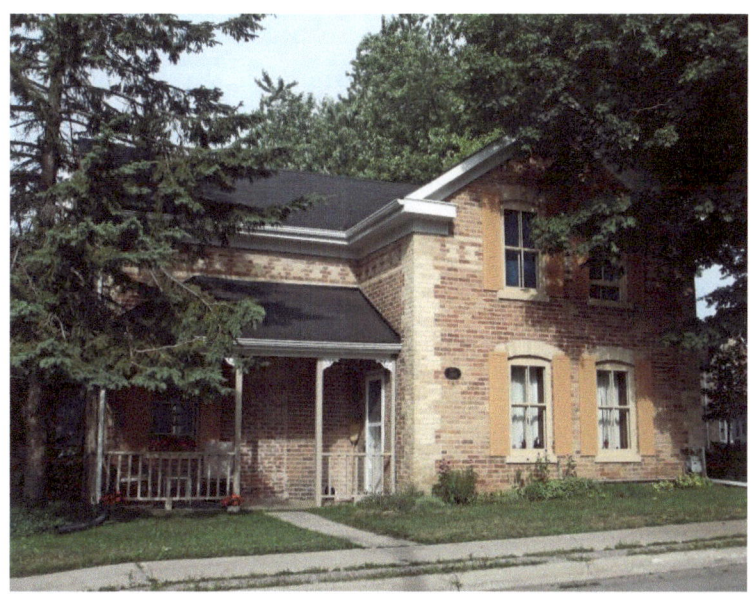

Built 1896 – Gothic Revival - dichromatic brickwork, cornice return on gable, buff-coloured window voussoirs

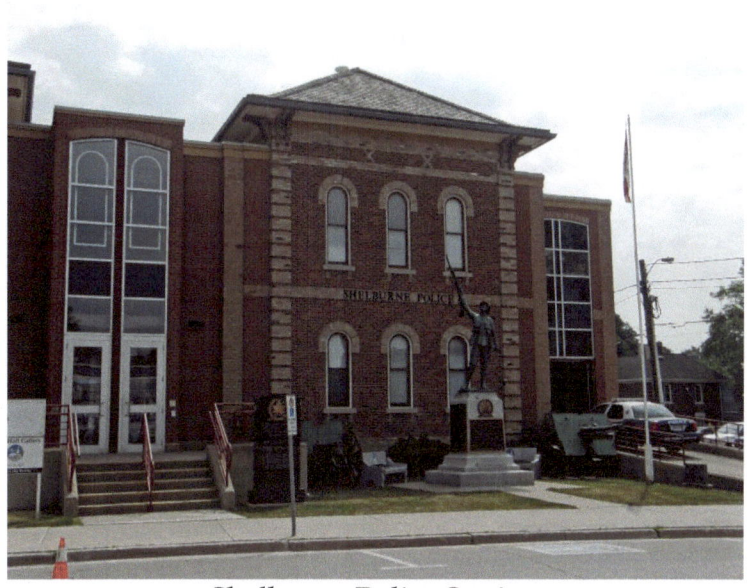

Shelburne Police Station

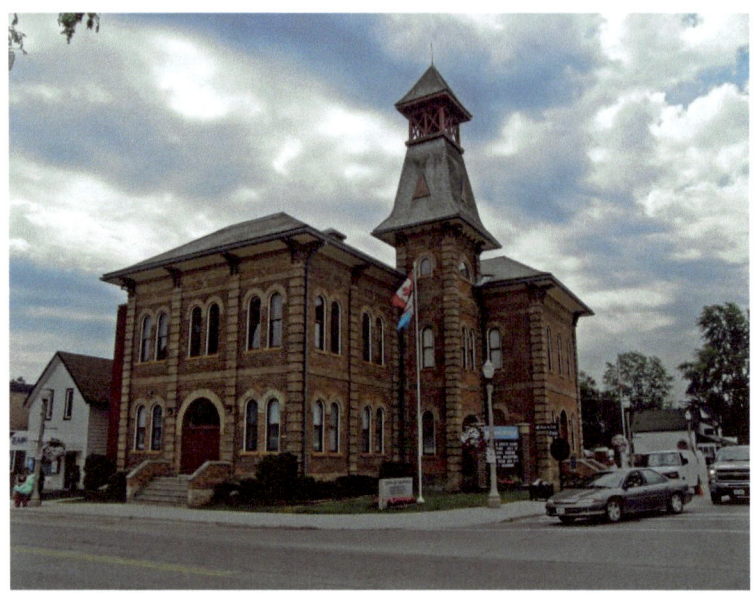

Town of Shelburne Administration, Grace Tipling Hall, Police Station - , corner of Main Street East and Victoria Street – Italianate style, paired cornice brackets, dichromatic brickwork, three-storey tower with cap and cupola

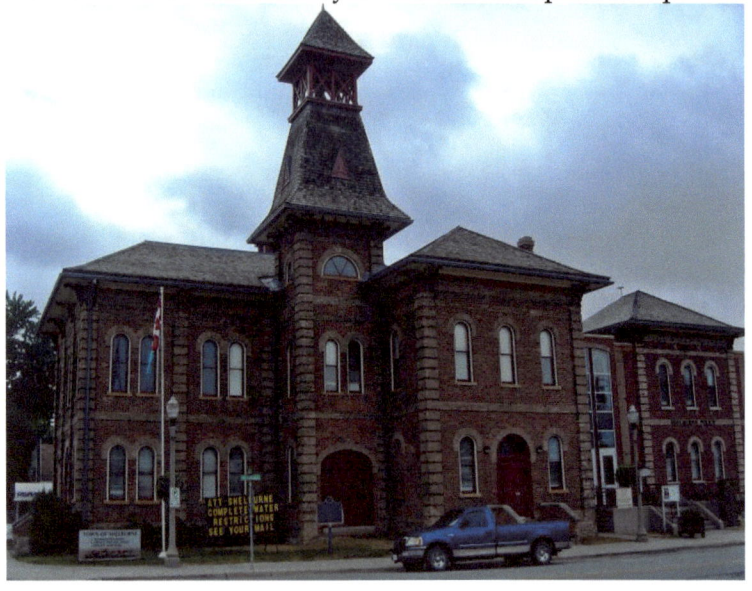

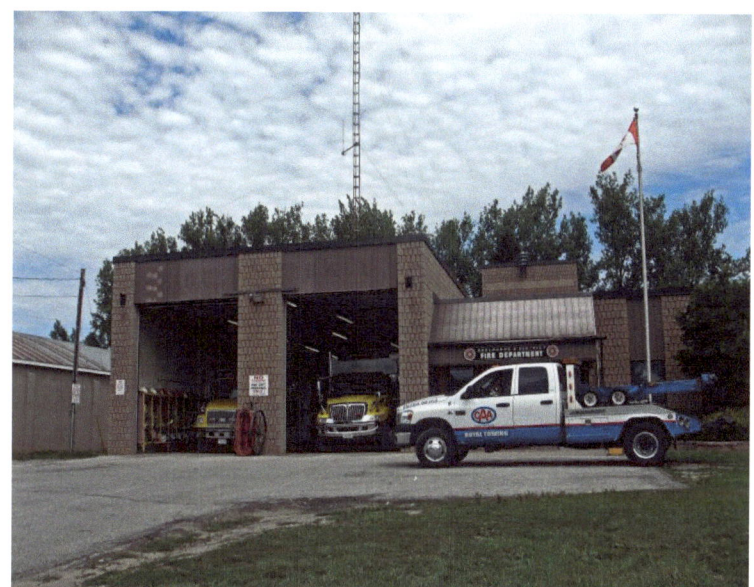

Fire Station

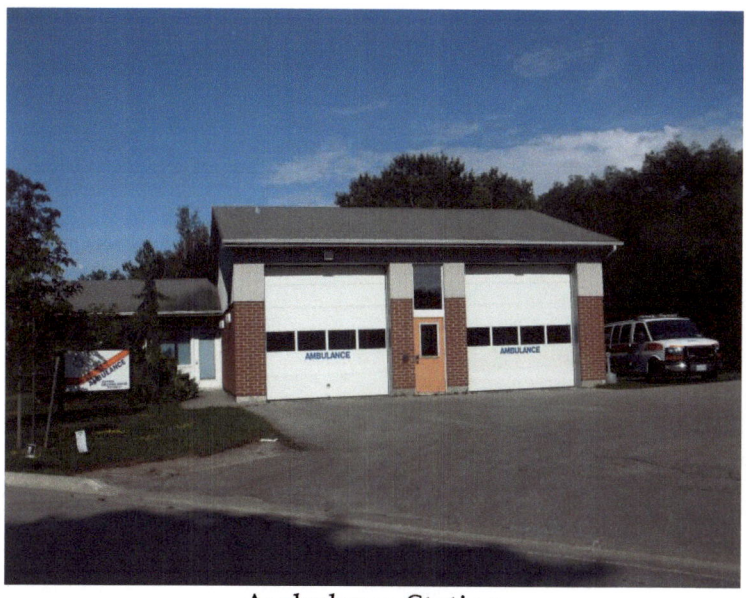

Ambulance Station

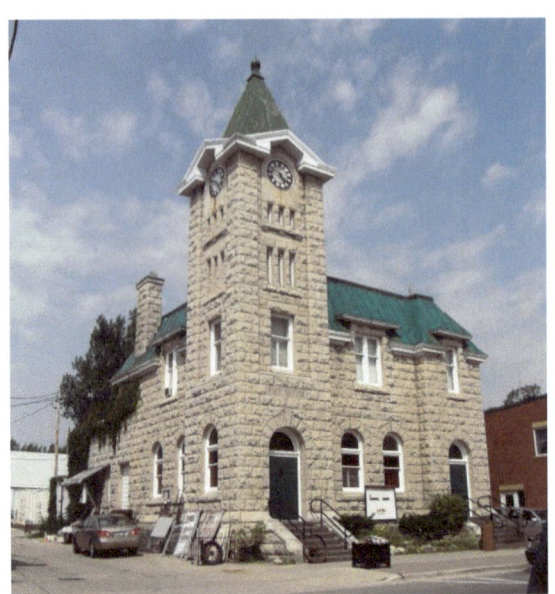
Post Office with clock tower

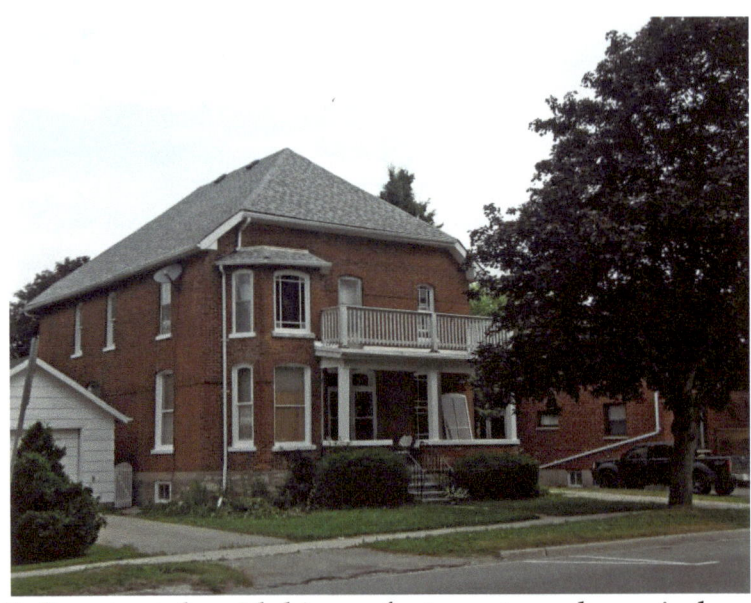
Italianate style with hip roof – two-storey bay window, balcony above verandah

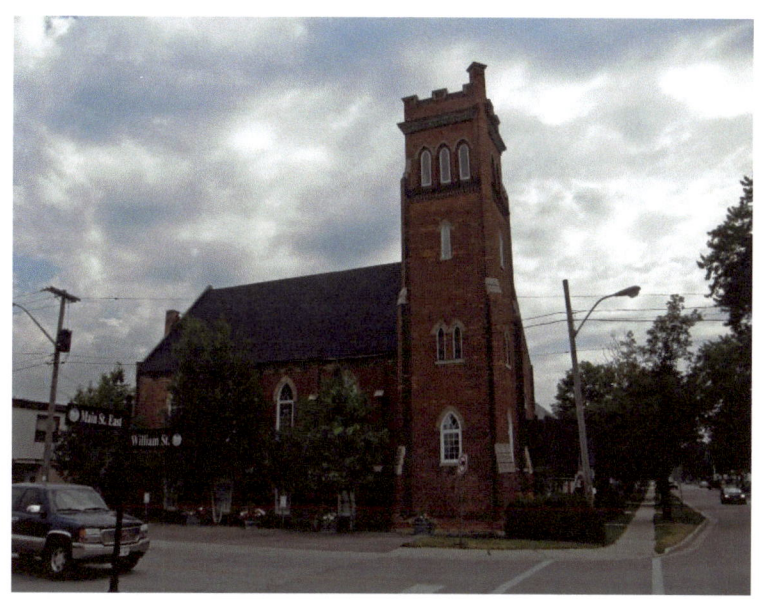

214 Main Street East - former Methodist Church
Built A.D. 1888 – Gothic Revival style – lancet windows, buttresses

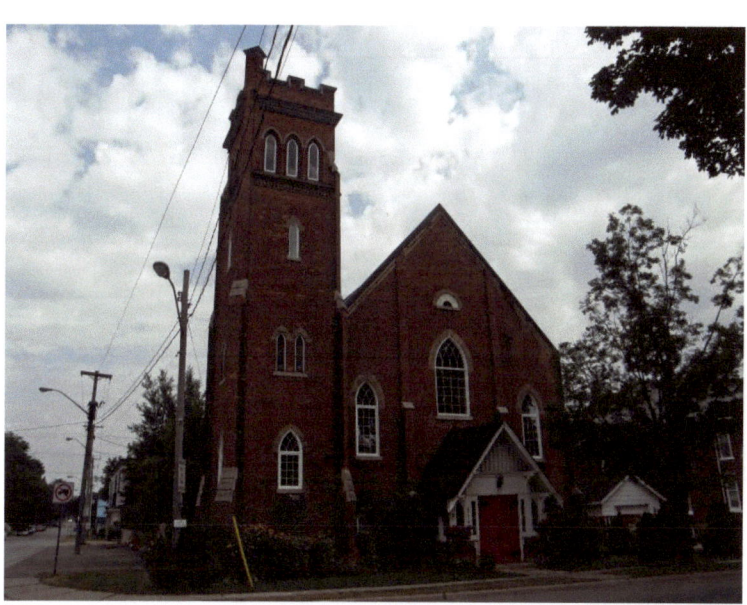

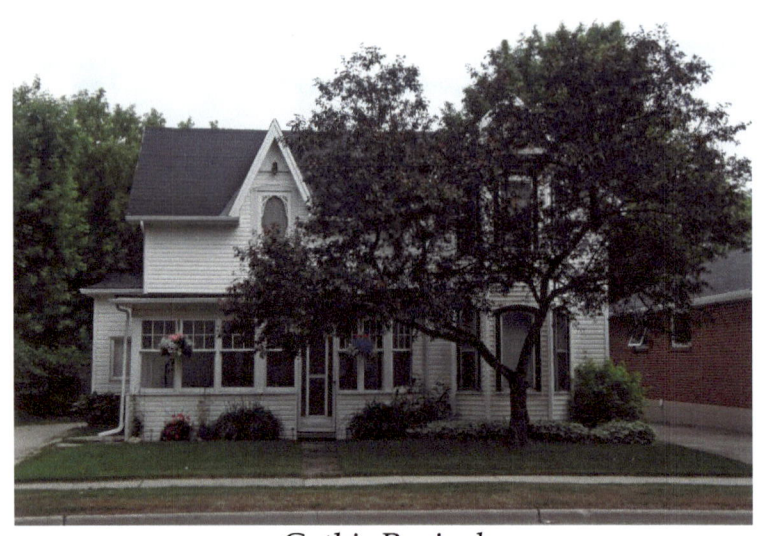

Gothic Revival

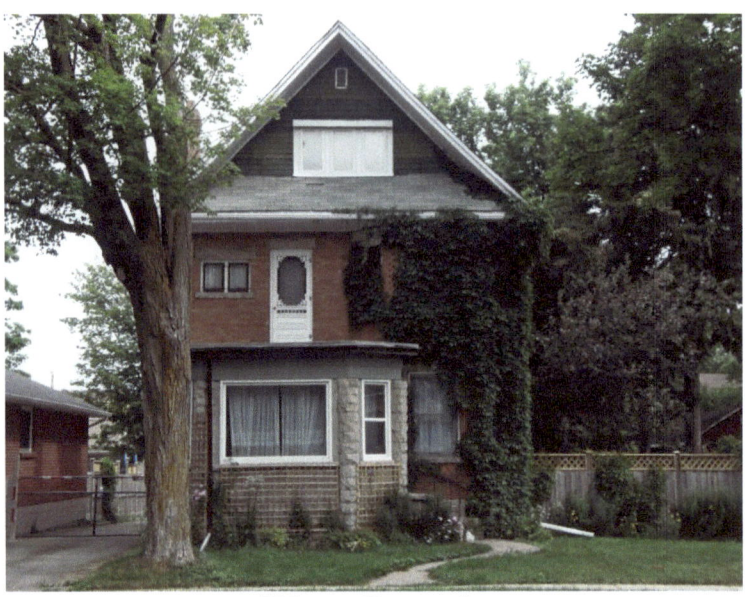

Edwardian style

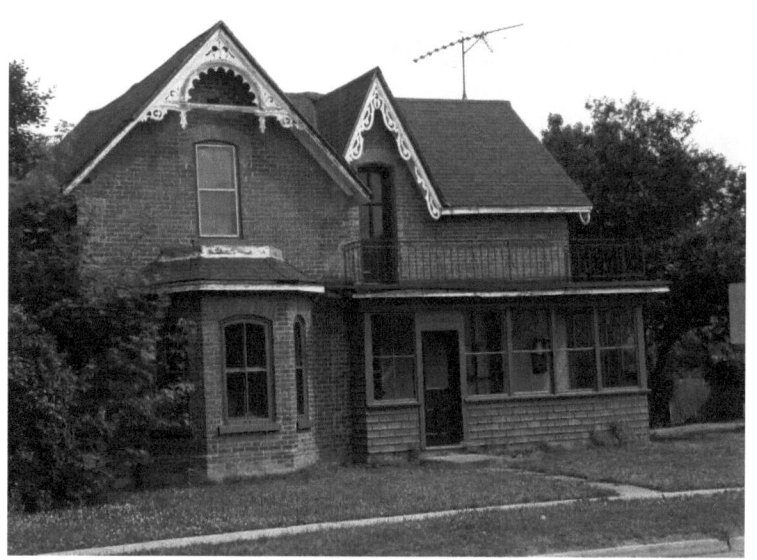

Gothic Revival with Vergeboard trim on gables

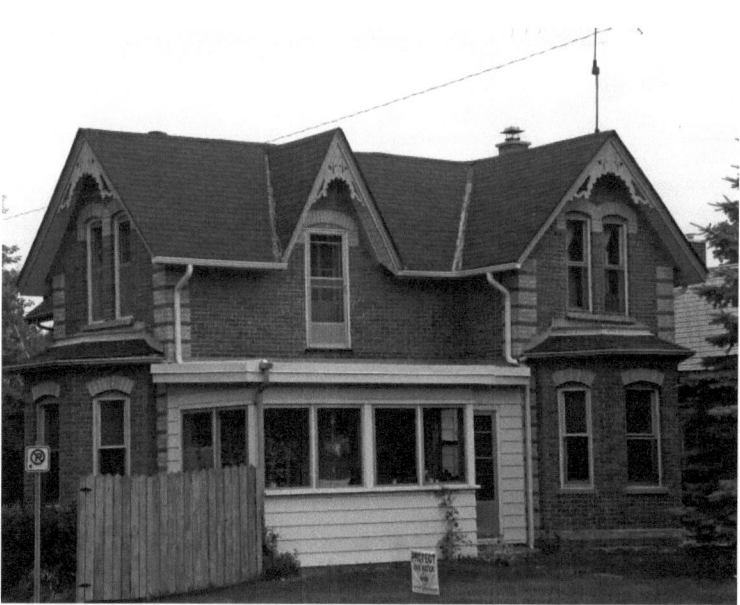

Corner quoins, buff-coloured window voussoirs, bay windows on ground level

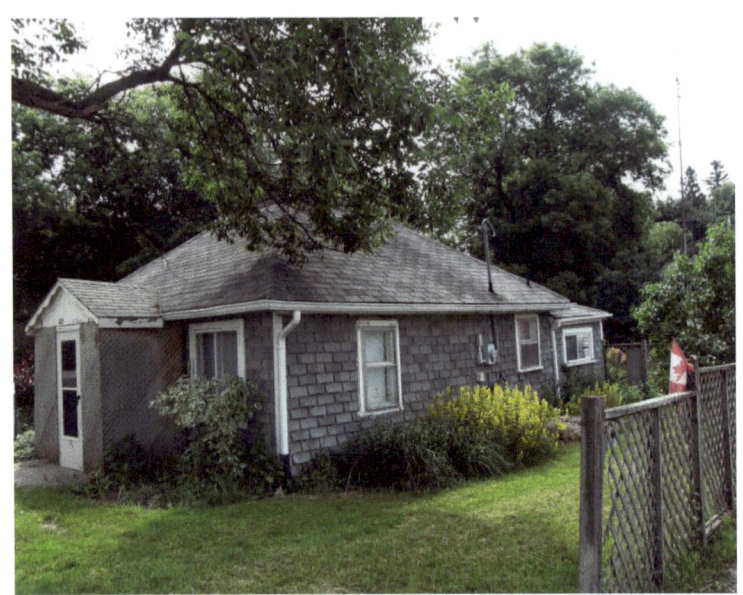

Cottage

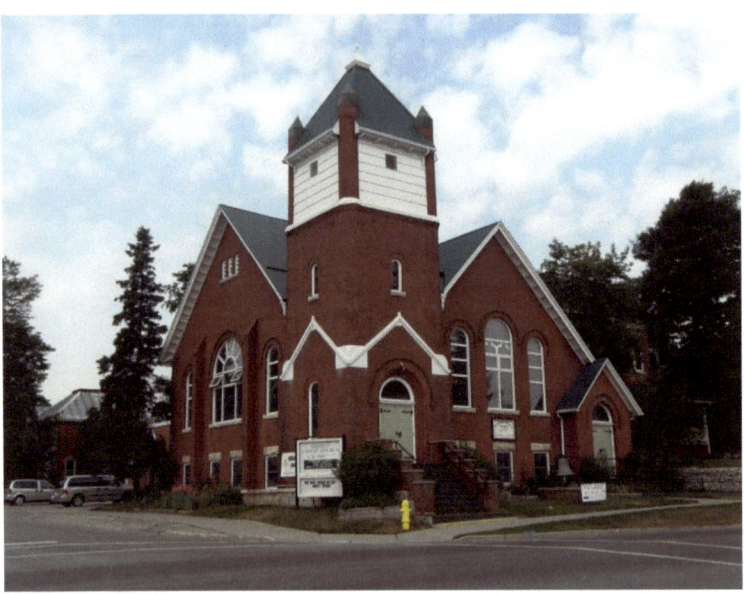

Trinity United Church – Gothic Revival

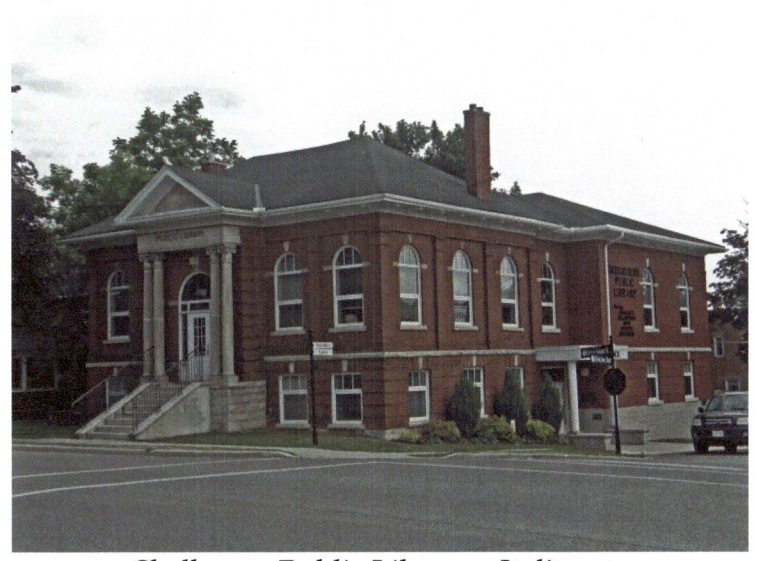

Shelburne Public Library - Italianate
Entranceway pillars with scrollwork capitals, pediment above

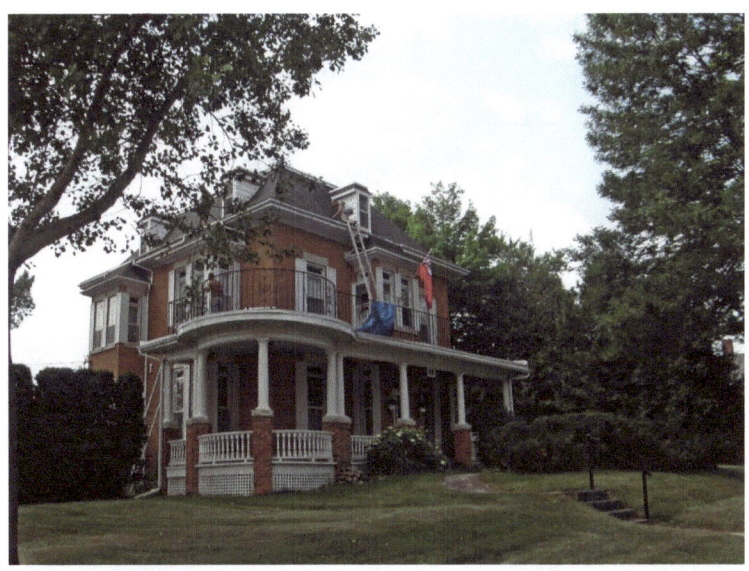

#111 - Italianate – dormers in attic, second storey balcony above verandah – House of Jelly built in 1891 by William Jelly

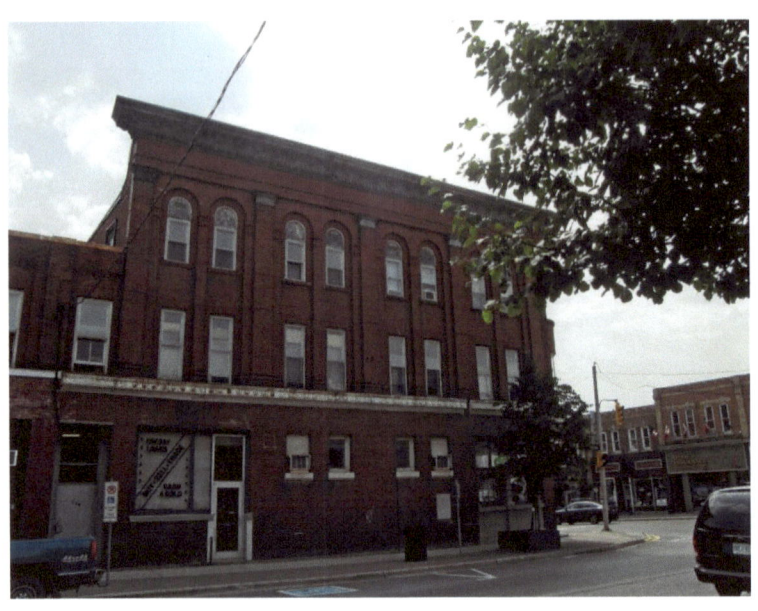

Downtown buildings with decorative brickwork

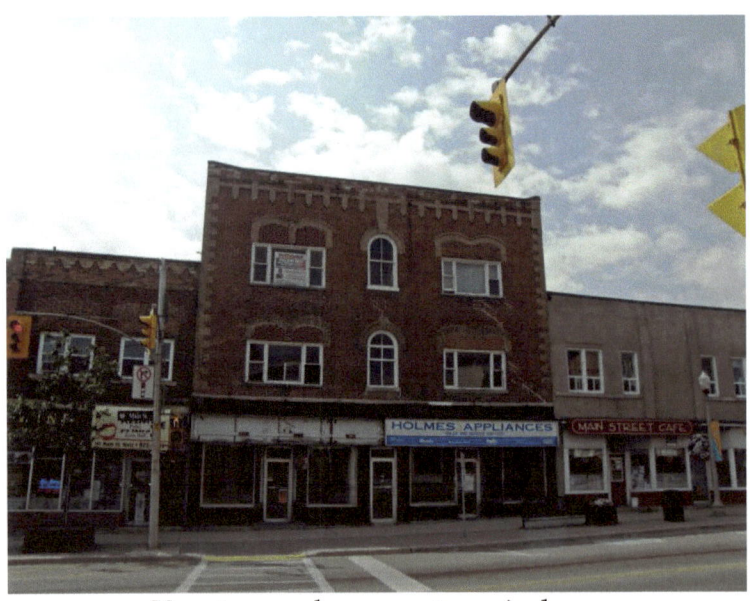

Keystones above centre windows

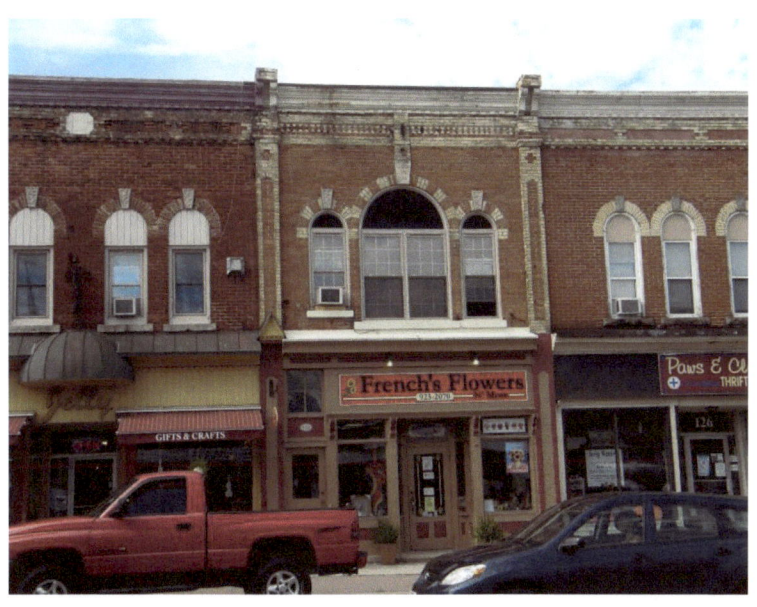

Dichromatic brickwork, voussoirs and keystones, dentil moulding

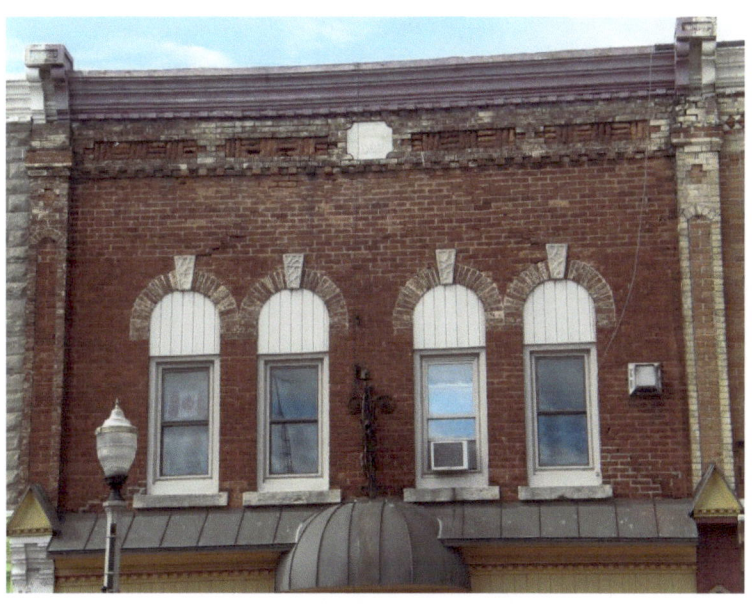

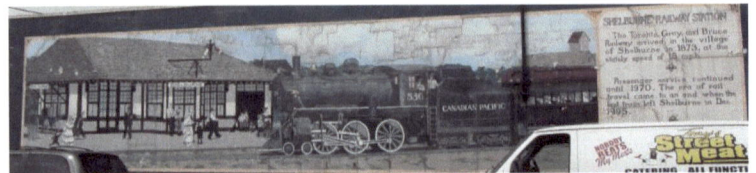

This scene depicts the Shelburne Train Station circa 1914.

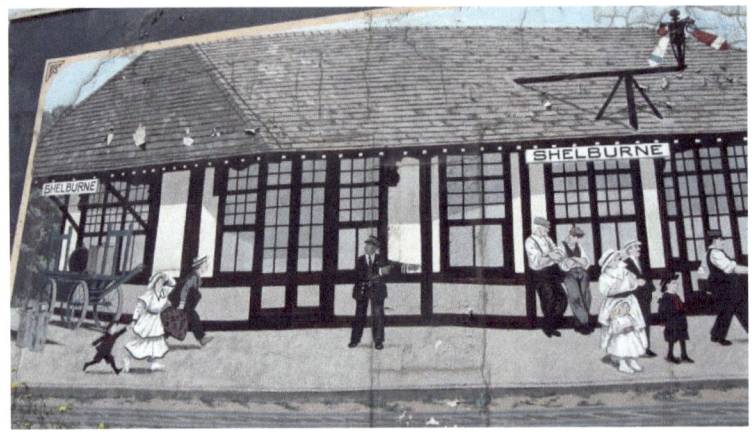

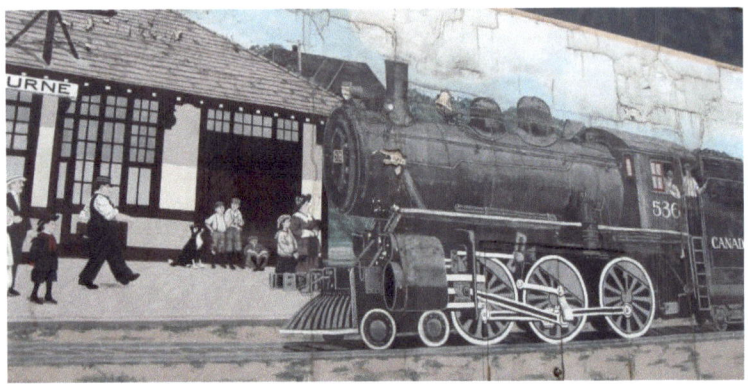

Shelburne Railway Station mural
The Toronto, Grey and Bruce Railway arrived in the village of Shelburne in 1873 at the stately speed of 15 m.p.h. Passenger service continued until 1970. The last train left Shelburne in December 1995.

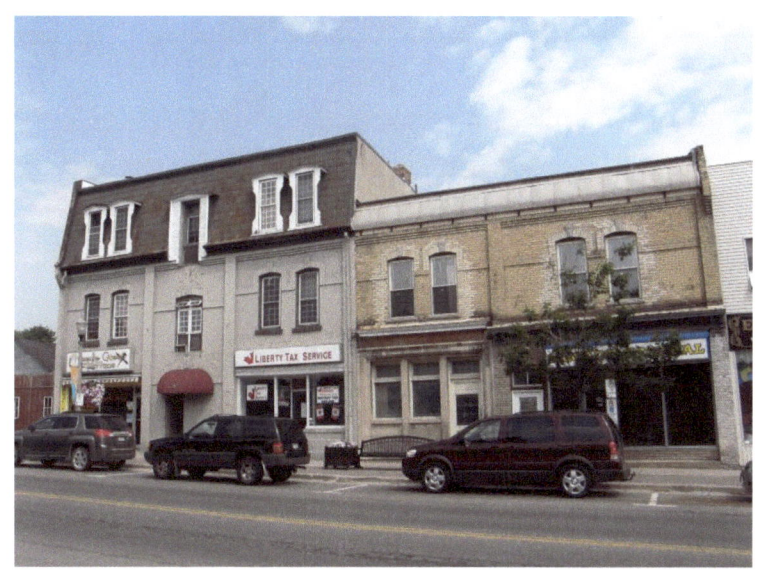

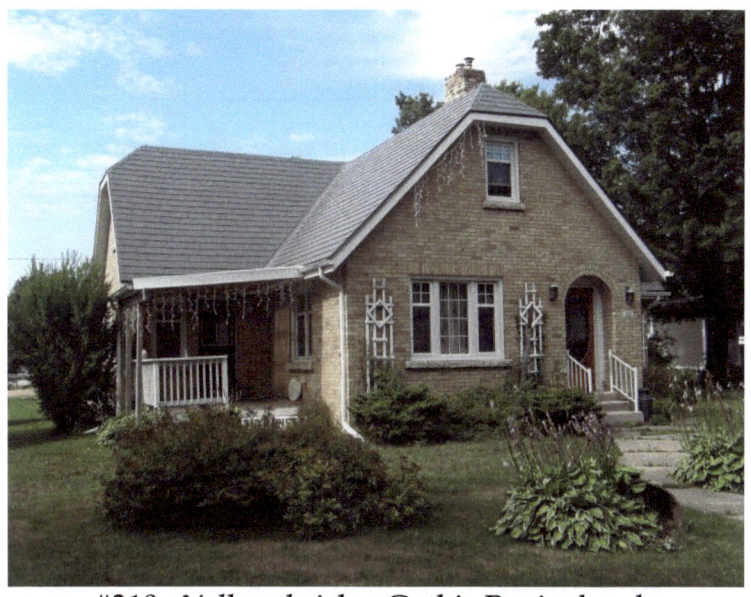

#310 - Yellow brick – Gothic Revival style

Two examples of Gothic Revival, dichromatic brickwork, corner quoins

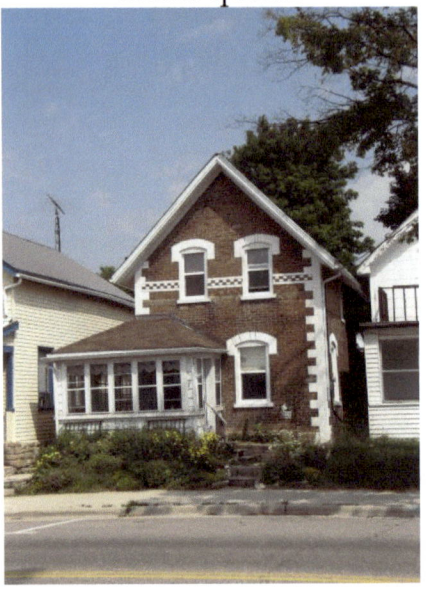

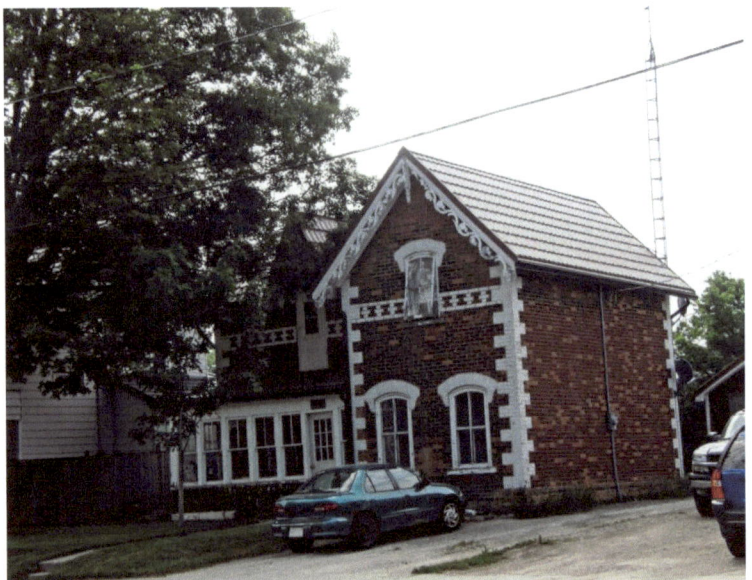

Vergeboard trim on gable with finial

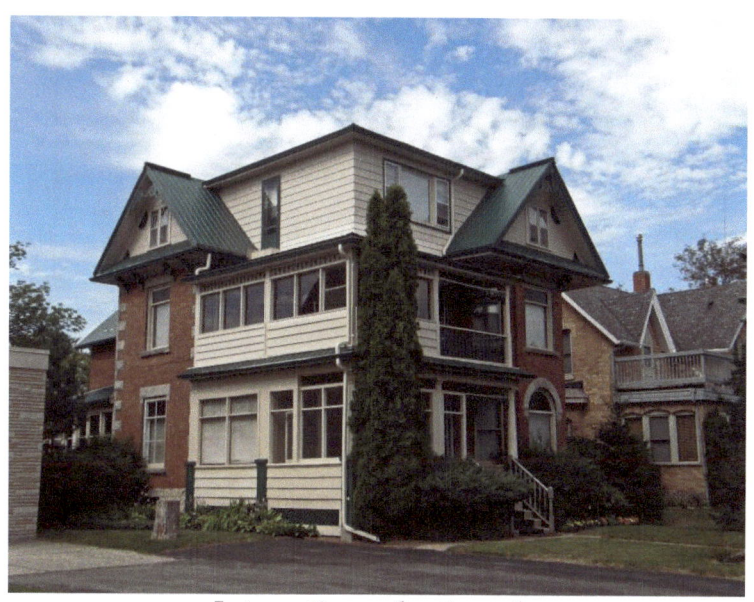

Interesting eclectic style

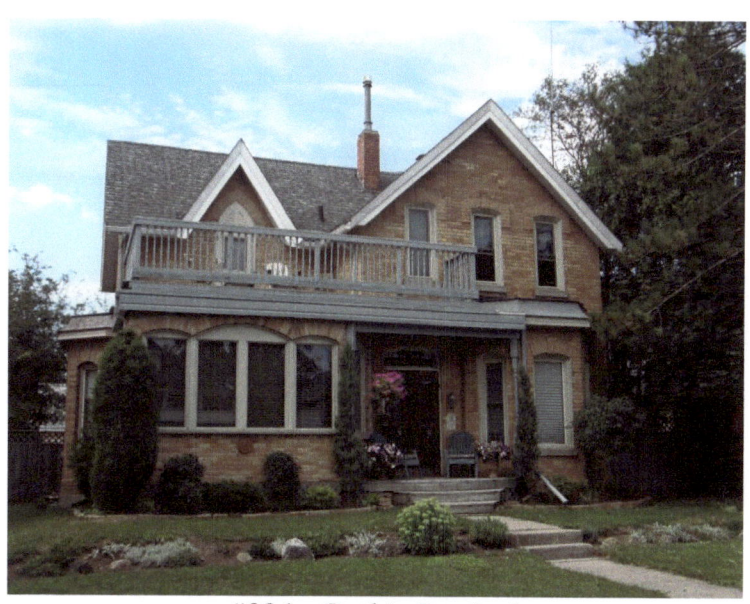

#326 - Gothic Revival

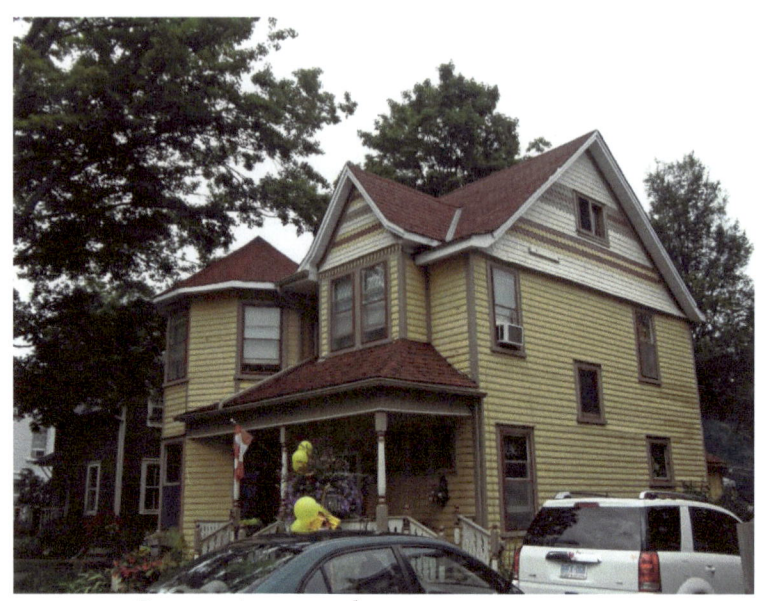

Queen Anne style – two-storey turret

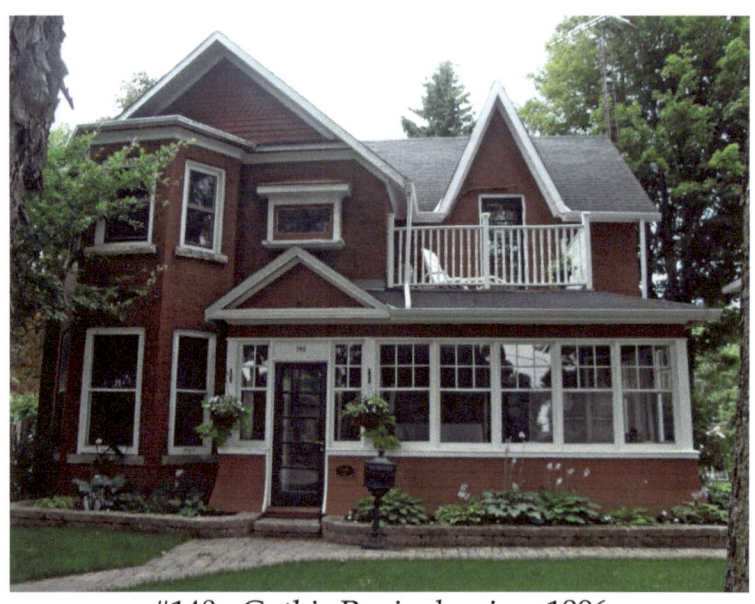

#140 - Gothic Revival – circa 1896

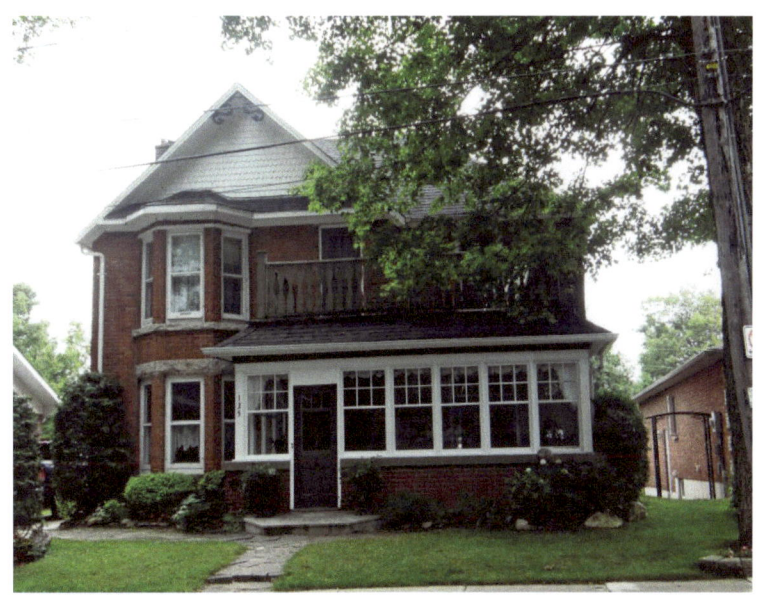

#135 – Gothic Revival, two-storey bay window

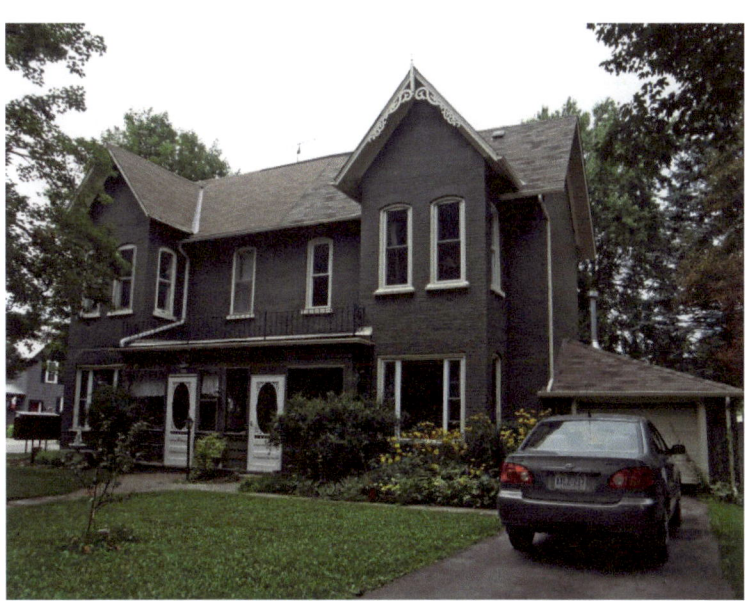

#148 - Gothic Revival with two-storey tower-like bays
The Mason House established 1883

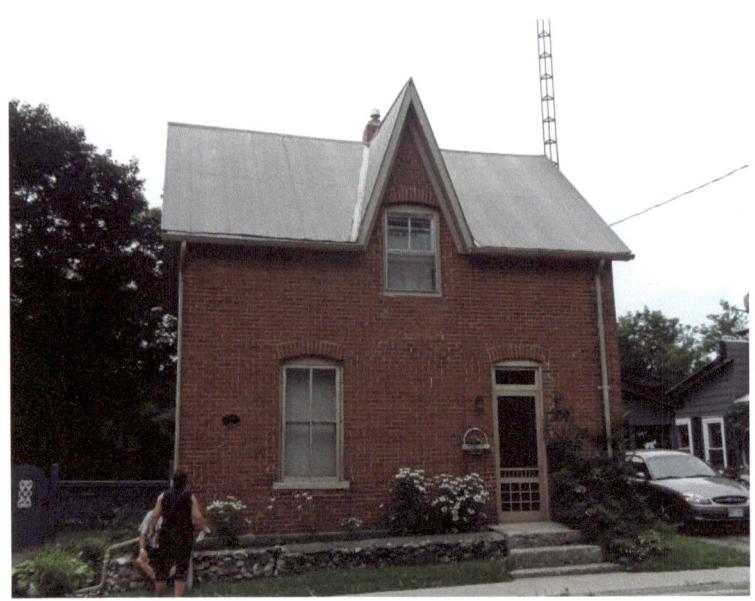

#200 – circa 1890 – Gothic Revival

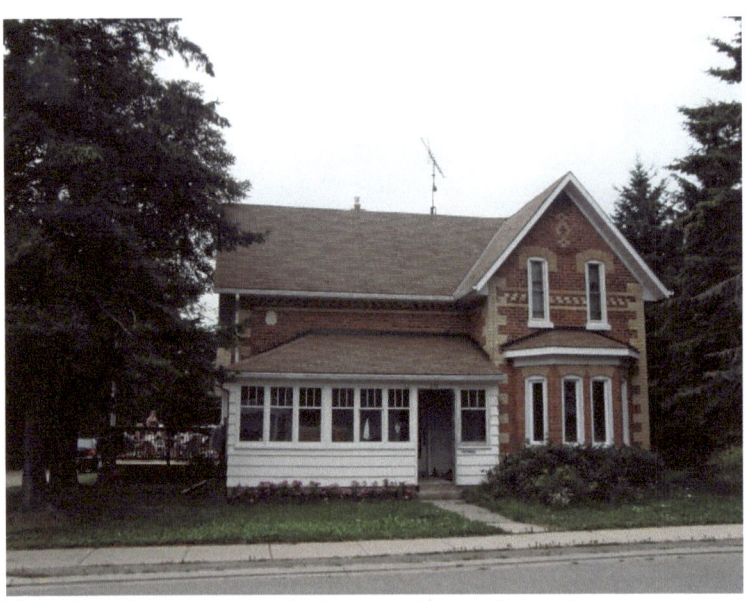

#212 – Gothic Revival, dichromatic brickwork, corner quoins

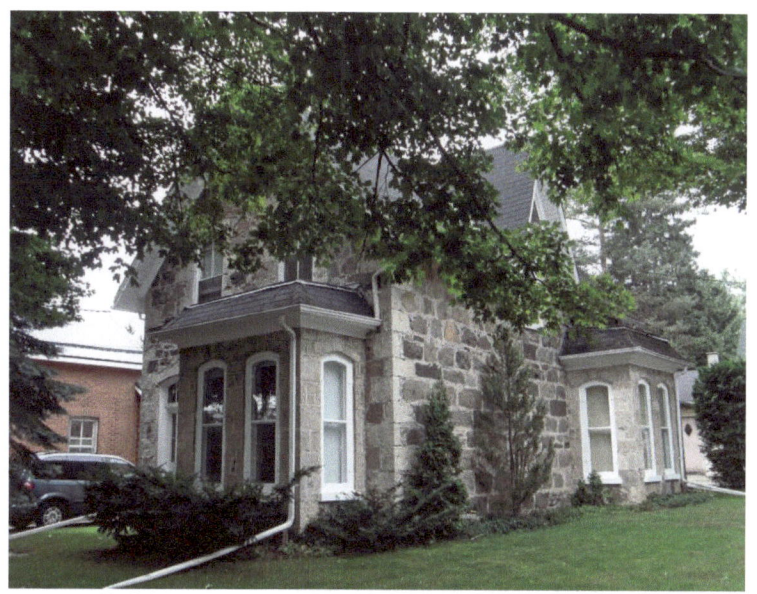

Cobblestone architecture – Gothic Revival

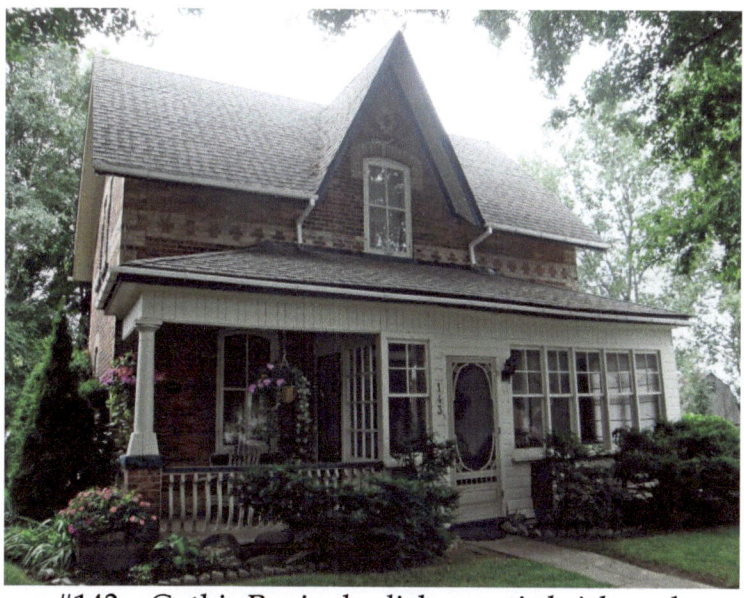

#143 – Gothic Revival - dichromatic brickwork

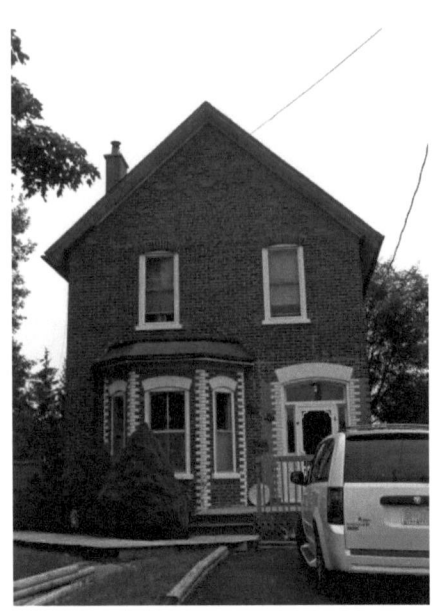

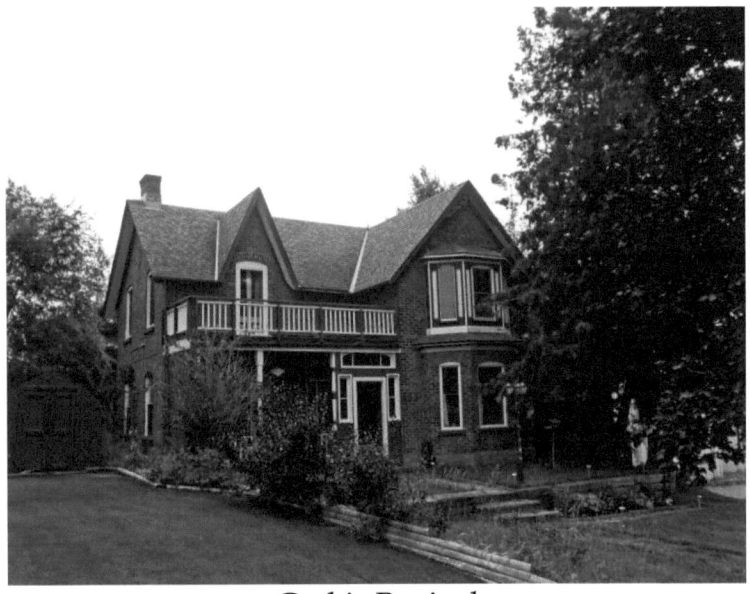

Gothic Revival

Melancthon

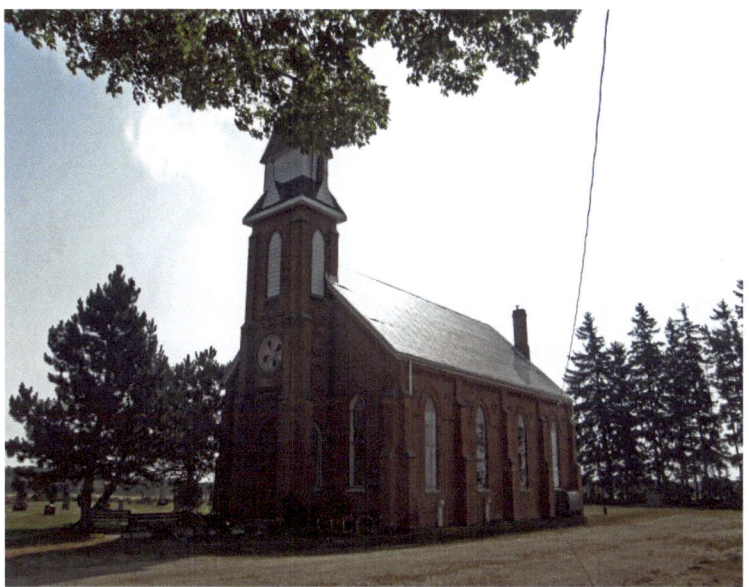

St. Patrick's Roman Catholic Church

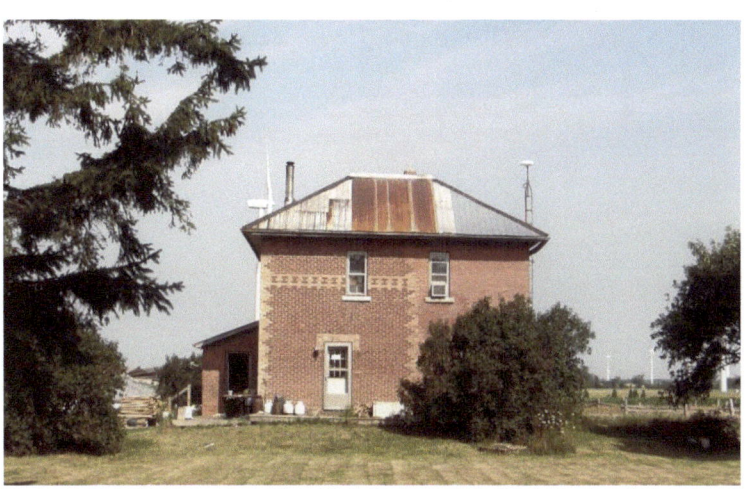

Italianate style - Dichromatic brickwork

Laurel

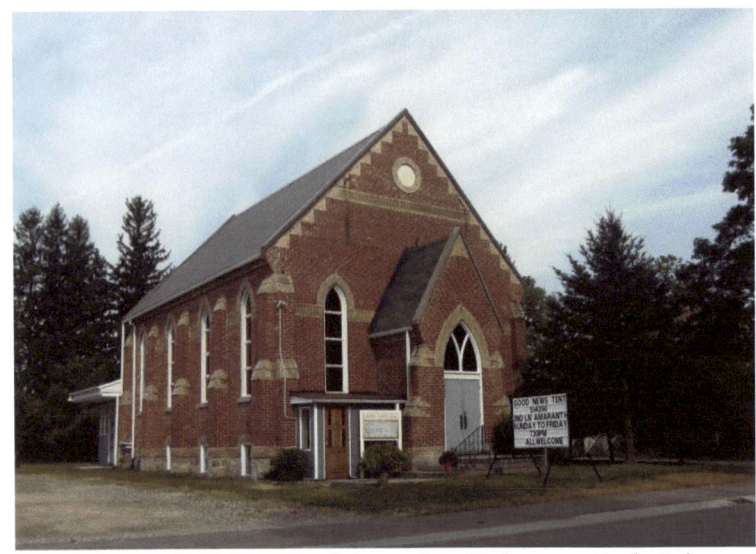

Laurel Gospel Hall – Gothic style, dichromatic brickwork, lancet windows

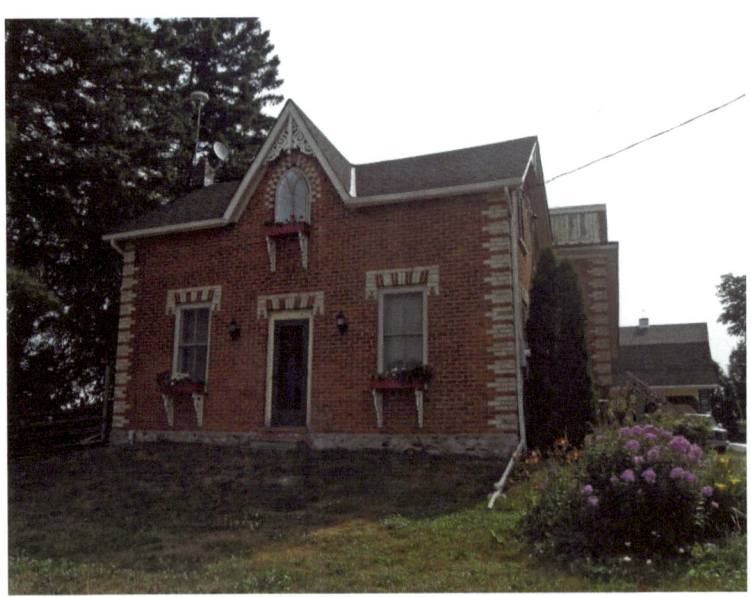

Gothic Revival – decorative vergeboard on gable, dichromatic brickwork, decorative rectangular window lintels

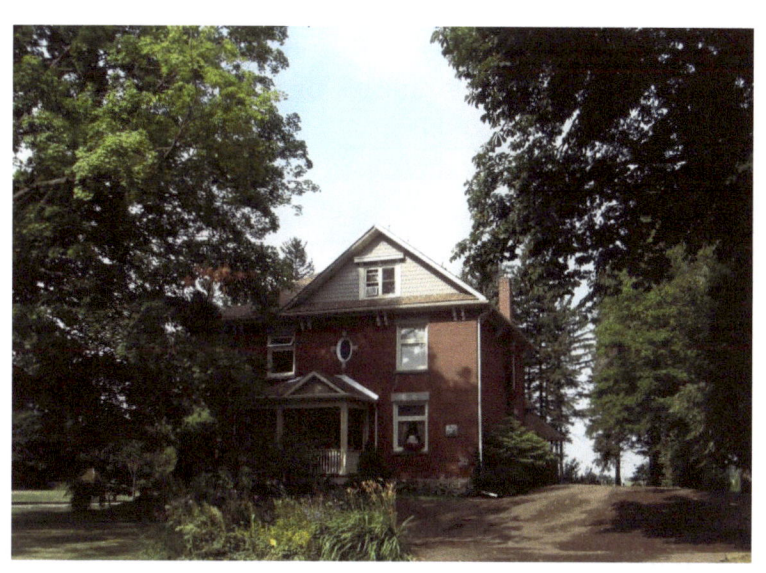

Architectural Terms

Brackets: a decorative or weight-bearing structural element which forms a right angle with one side against a wall and the other under a projecting surface such as an eave or roof. Example: Shelburne Town Hall	
Cobblestone architecture: Refers to the use of cobblestones embedded in mortar as a method for erecting walls on houses and commercial buildings.	
Cornice: originally the wooden overhang of the roof. With the use of stone, brick, iron and steel, the cornice is any projecting shelf at the top of a ceiling or roof. They can be very decorative.	
Cornice Return: decorative element on the end of a gable.	
Dormer: (French for "sleep") a gable end window that pierces through the plane of a sloping roof surface to create usable space in the top floor or attic of a building by adding headroom. Example: #111 – Jelly House	
Finial: ornament added to the top of a gable, pinnacle, canopy or spire – a Gothic element.	
Gable: the triangular portion of a wall between the edges of a sloping roof.	

Hipped Roof: a roof where all sides slope downwards to the walls with no gables.	
Keystones and Voussoirs: a voussoir is a wedge-shaped element used in building an arch. A keystone is the central stone that locks all the stones into position, allowing the arch to bear weight. A keystone is often enlarged and embellished.	
Pediment: a triangular section above the horizontal structure (entablature), typically supported by columns. The inside of the triangle is called the tympanum. Example: Shelburne Public Library	
Turret: a small tower that projects from the wall of a building. Example: 230 Owen Sound Street	
Vergeboards: also called bargeboards (gingerbread) – hang from the projecting end of a roof and are often elaborately carved and ornamented.	

Shelburne's Building Styles

Edwardian, 1900-1930 – This style bridges the ornate and elaborate styles of the Victorian era and the simplified styles of the 20th century. Balanced facades, simple roof lines, dormer windows, large front porches, and smooth brick surfaces are its characteristics.	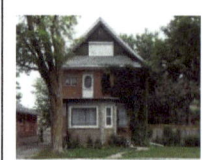
Gothic Revival, 1830-1890 – These decorative buildings have sharply-pitched gables with highly detailed vergeboards, pointed-arch window openings, and dichromatic brickwork. It is a common style in Ontario. Example: #148 – The Mason House	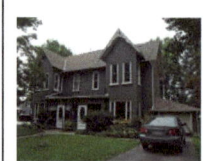
Italianate, 1850-1900 – It has wide-bracketed eaves, belvederes, wrap-around verandahs.	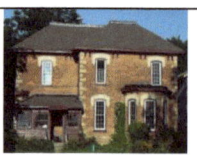
Queen Anne, 1885-1900 – This style is distinguished by an irregular outline featuring a combination of an offset tower, broad gables, projecting two-storey bays, verandahs, multi-sloped roofs, and tall, decorative chimneys. A mixture of brick and wood is common. Windows often have one large single-paned bottom sash and small panes in the upper sash. Example: 230 Owen Sound Street	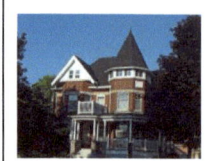

www.ingramcontent.com/pod-product-compliance
Lightning Source LLC
Chambersburg PA
CBHW041610180526
45159CB00002BC/798